P9-DNG-457

YOU & ME
&
WHY WE
ARE IN LOVE

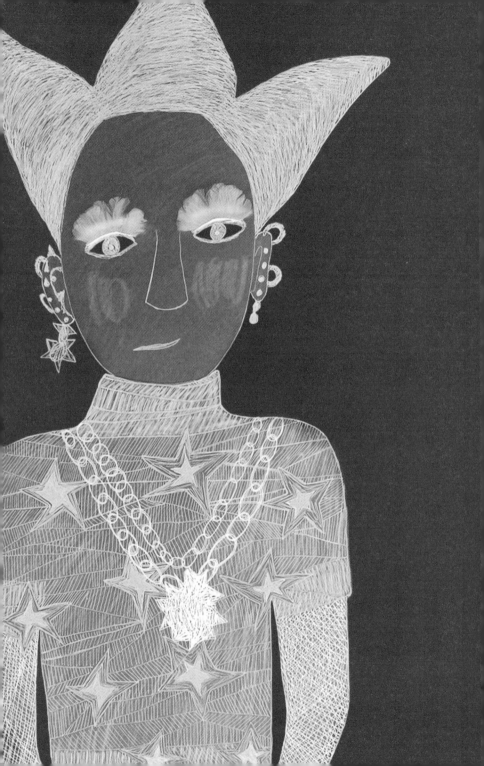

YOU & ME
&
WHY WE
ARE IN LOVE

Aurelia Alcaïs

PENGUIN BOOKS

PENGUIN BOOKS

An imprint of Penguin Random House LLC

375 Hudson Street

New York, New York 10014

penguin.com

First published in Italy as *Toi et moi* by Maurizio Corraini s.r.l. 2015

This expanded edition published in Penguin Books 2018

Copyright © 2015, 2018 by Aurelia Alcaïs

Translation copyright © 2015 by Aurelia Alcaïs, Francesca Cantinotti, and Robin King

Penguin supports copyright. Copyright fuels creativity, encourages diverse voices, promotes free speech, and creates a vibrant culture. Thank you for buying an authorized edition of this book and for complying with copyright laws by not reproducing, scanning, or distributing any part of it in any form without permission. You are supporting writers and allowing Penguin to continue to publish books for every reader.

All illustrations are by the author.

LIBRARY OF CONGRESS CATALOGING-IN-PUBLICATION DATA

Names: Alcaïs, Aurelia, author.

Title: You & me & why we are in love / Aurelia Alcaïs.

Other titles: Toi et moi. English | You and me and why we are in love

Description: New York : Penguin Books, 2018. | Contains the English versions of the short poems originally published in English, French, and Italian in the book Toi et moi (Mantova : Corraini, 2015).

Identifiers: LCCN 2017022293 (print) | LCCN 2017039464 (ebook) | ISBN 9781101992708 (ebook) | ISBN 9780143110699 (paperback)

Subjects: | BISAC: FAMILY & RELATIONSHIPS / Love & Romance.

Classification: LCC PQ2661.L33 (ebook) | LCC PQ2661.L33 T8613 2018 (print) | DDC 841/.914—dc23

LC record available at https://lccn.loc.gov/2017022293

Printed in the United States of America

1 3 5 7 9 10 8 6 4 2

Set in Garamond Premier Pro

FOR

. .

and all those who believe in love.

Love for animals

Christina loves pets, especially dogs.
She calls them her "sweet kids."
Sometimes she wonders
if their love is driven by food.

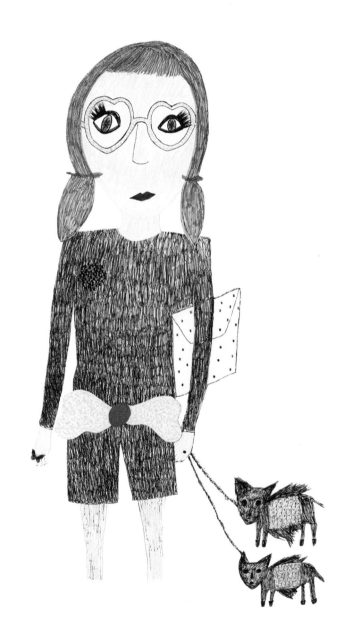

Love for country

José cries each time he thinks
about his country.
He misses Catalonia, so far away!
He loves Barcelona.
He swears he will only marry a Spanish girl!

Astrological love

Jacqueline likes reading about the planets
and how they influence human beings.
Astrology inspires her.
She consults the horoscope.
She doesn't want to end up with another shooting star!

Swinging love

Vincent invited Elizabeth to a party.
They danced all night long, and afterward,
they fell asleep in the same bed.
Early in the morning, they put on their shoes
and went back to their own places.

Brand new love

Pamela has found a very young lover.
He could be her son.
She doesn't love him—she adores him.

Gambling love

Jeanne and Timothy adopted a cat
to prove they love each other.
They don't know whether to call it
Perfect or Catastrophe.

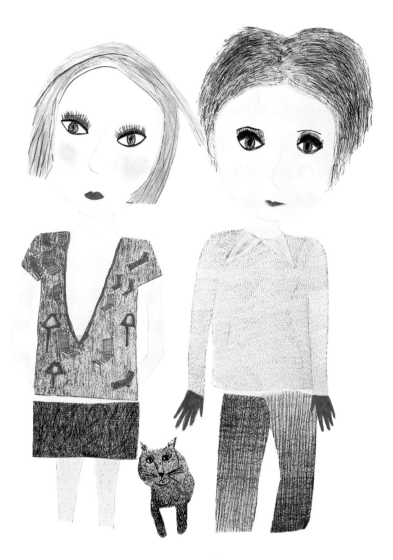

Modern love

George and Mike just met on a dating site.
For the moment, they are very happy about
their encounter, but they are taking it one day at a time.
They say: "Let's just see how it goes . . ."

Coincidences in love

Peter and Mia shouldn't have met,
but they boarded the same train.
Suddenly, the train stopped and they started talking.
They talked so much that
they are still talking, even now.
Today they have two children:
Luna and Gaspard.

The price of love

Laurent and Sylvie were both free.

They didn't like being lonely.

They took up the challenge of building

a relationship together.

They were born on the same day,

but who knows if that will bring them good fortune?

The end of love

Colette changed her life and her clothes.

She opted for a new life.

She separated from her husband.

It's time for spring cleaning.

Her gray days are over, and now she dreams
about colorful clothes.

Qualified love

Aki and Kimori never leave their screens.
They sleep with their smartphones connected.
They communicate by email.
They doubt nothing, are sure of everything.
They have attended a prestigious school,
and they feel invincible.

Neighborly love

Valerie admires her next-door neighbor.
She wants to open her heart to him.
But first, she must fill out
her tax forms, clean up her flat,
vacuum, take a bath,
dust her desk, call her mother, and water the plants.
Will she dare ring his doorbell?

Love in disguise

Leonard loves to dress up as a superhero.
One day, he will marry a superwoman.

Clairvoyant love

Nicole has started a course in divination and tarot cards
so as to find a lover who is perfect for her.

It takes up all her time!

Inquiring love

Toscan and Rosemary love art.

They travel together to find treasures.

Nobody knows what they are looking for,

but who cares? They seem happy.

By the way, no one has ever seen them apart.

Divorced love

Peggy's divorce cost her an arm and a leg,

so she's not in a hurry to get remarried.

"Don't worry about me," she says.

"I've got a big family and a lot of friends!"

Hot and cold love

Hippolyte and Nadine don't know
if they love each other anymore.
They decided to go out for an ice cream.
An ice cream to warm up their love.

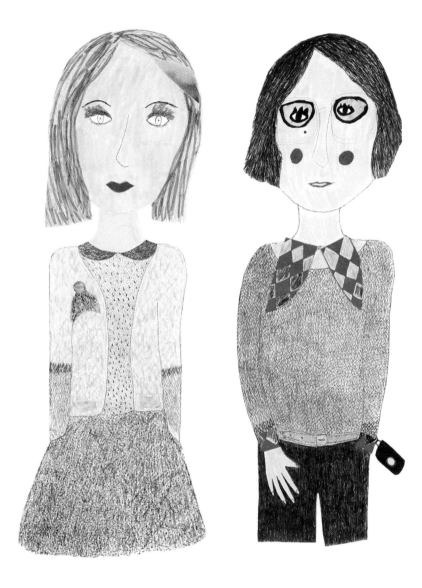

Romantic love

Each Saturday, David buys flowers for his wife.
They have been in love for twenty years.
They have three kids.
Rosalie is the love of his life,
there is no doubt about it.

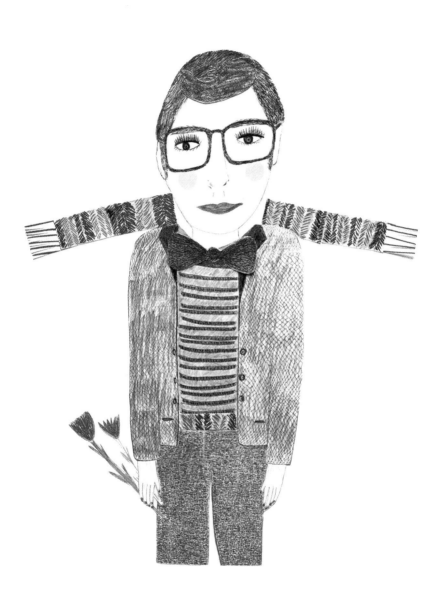

Complicated love

Emma is looking for a lover
who is not too tall and not too hairy.
A beautiful man, funny but not too funny.
Smart, but not a genius—that's too complicated.
Sensitive but not weak.
A brown-haired fellow would be good.
Even better if his shoes are size 10.
A pianist is okay, but not a drummer.

Mellow love

Louis is a surgeon—he cuts open stomachs.

Chiara pulls out teeth.

In the evening, they love each other calmly.

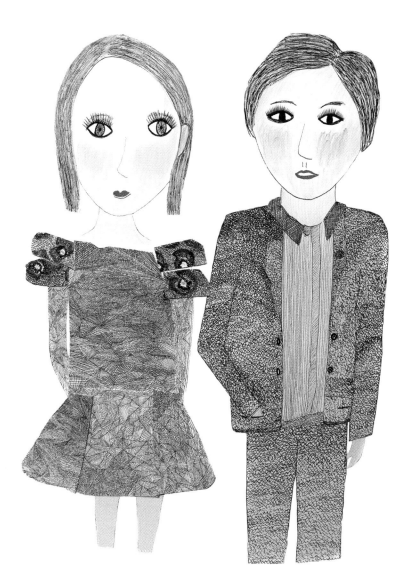

Hypnotic love

Mila sees her hypnotist three times
a week to cure herself from love.
She expects to be healed from this curse
once and for all.

King-size love

Delphine has seven children and
won't stop there.
Every weekend, her husband demands they
go to the forest. She doesn't object. He is a lumberjack,
and he chops down trees.

Love of travel

Jean-Paul travels so as not to stay alone at home.
He loves adventure, and adventure loves him.
He just got his scuba-diving permit
with congratulations from the teacher.

Love at first sight

Tom and Jessica are English.

They met in a French class.

It was love at first sight.

They moved together to Paris

to fulfill their dreams and to eat baguettes.

They found Paris as lovely as they expected.

They are thinking of getting married.

Sleeping love

Inès works a lot.

For the moment, she isn't looking for a lover
but for a degree.

One day, she will wake up.

For the moment she eats chocolate.

Impossible love

Inga and Alexis don't ask themselves
if they love each other.
They are brother and sister.
They know that one day they will find love.
Who knows if they will be able
to appreciate their brothers-
and sisters-in-law?

Wild love

Daisy loves nature.

Flowers love Daisy.

She has a green thumb.

She dreams of having an elf as a gardener.

The love of detail

Laure understands why her marriage works.
In bed, her husband sleeps on the left,
so his heart is next to her.
(Her ex-lovers slept on the right,
which was a sign of power.)
She wants to write a book about her discoveries.

Scientific love

Séraphin isn't in love right now,
but that's not the end of the world.
He has statistics that prove
the feeling will come back.
Like a good mathematician, he says,
"There are 2,976,248,000 women in the world,
so when the time comes,
I'll find one for me, no?"

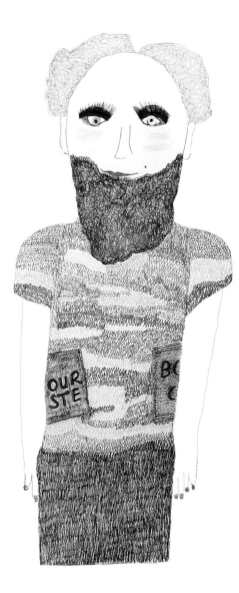

Mishmash love

Girls love boys.

Boys love girls.

Girls love girls.

Boys love boys.

Boys love girls.

Girls love boys and blah blah blah.

Driving love

Arun met his wife waiting in line
for a cab at the airport.
By chance, they both got into the same cab
later that week.
New York City is big.
It must be destiny!

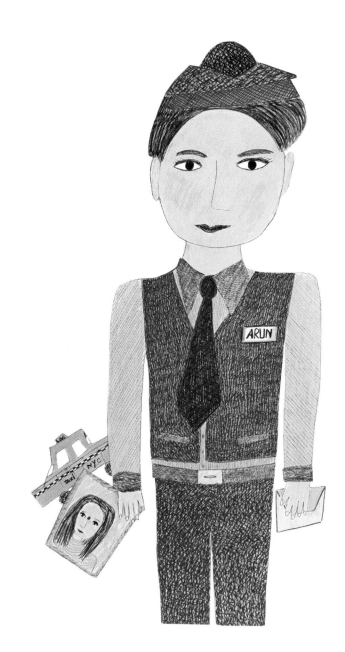

Butterfly love

Suzanne loves boys and butterflies too.
Her friend Julie calls her Miss Casanova.
She doesn't care, she says:
"Seduction keeps me young."

Managing love

Conception likes to manage all aspects of her relationship.
She decides everything: the house, the holidays,
the meals, the friends . . .
Her husband doesn't complain—
on the contrary!
She has found the right man.

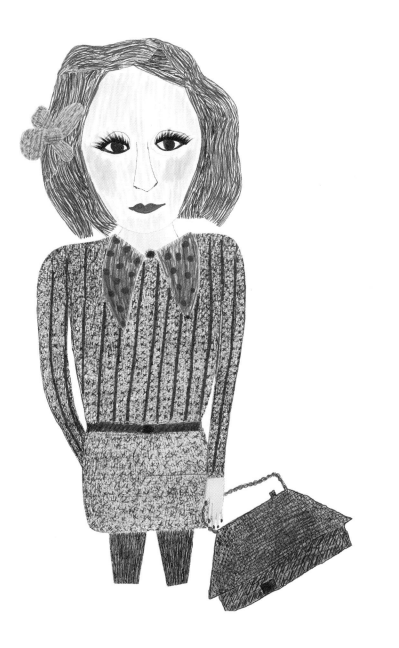

Revealing love

Noah lost all his hair when he left Sam.
For the Greeks, it is a sign of mourning.
For him, it's a total rebirth:
he changed his city, job, and home.
At last, he is himself!

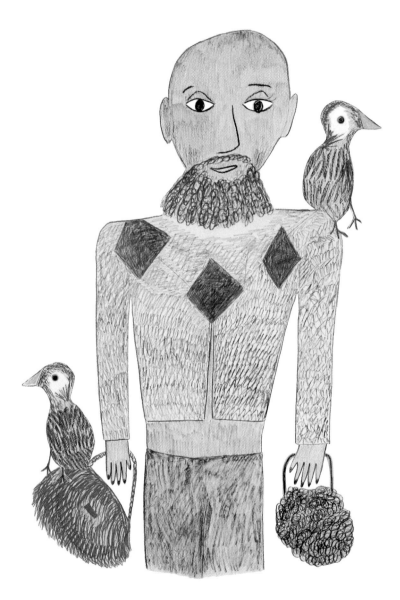

Illuminating love

Tuna left his wife because
she drank too much whisky.
He seeks comfort by purchasing lamps.
He wants them to be sober, tall, and thin.

Movie love

Marie-Caroline wants to meet Peter Pan.

She wishes to fly with him.

She thinks he's really fantastic.

They would be a perfect match.

He is the perfect lover—she just needs to find him.

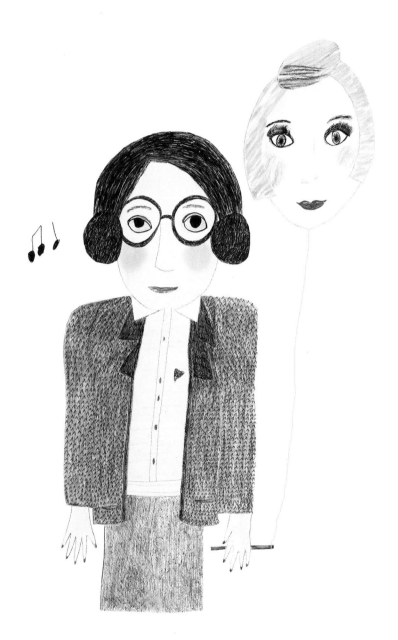

Athletic love

These days, Zach feels fragile.
He keeps away from love and
puts all his energy into sports
to improve his physical powers.
He doesn't want to fall into the same old traps.

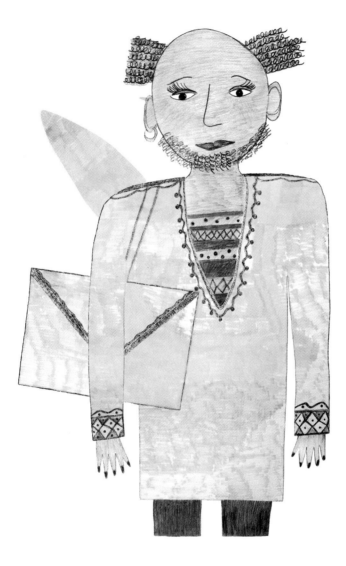

Punk love

Jean admires his grandma.
She is perfect.
He would like to find
a woman just like her.

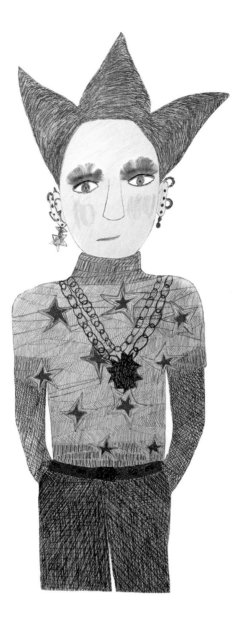

Speedy love

Penelope and Steve have moved to a new house
three times. They have changed jobs
five times and separated
four times.
They are not tired.
On the contrary, they think their life is exciting.

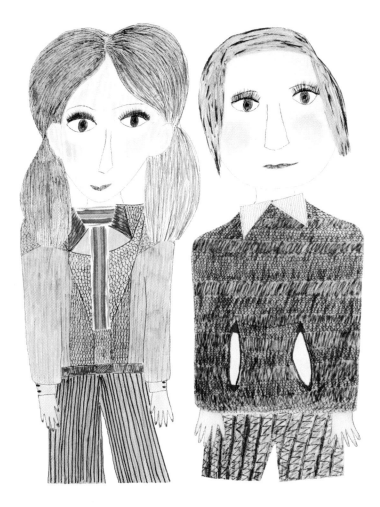

Acrobatic love

Frida loves the hula hoop.

Her lover is an acrobat.

Their love is like a big-top circus.

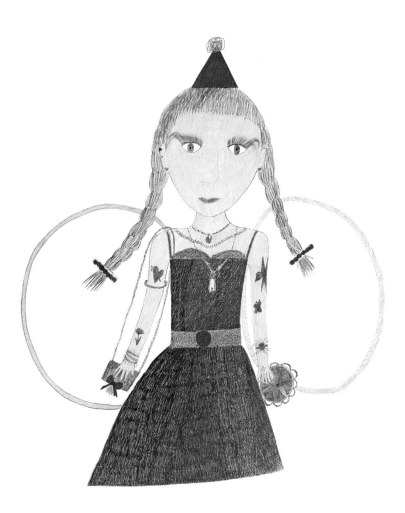

Growing love

Poppy and Jenny are going to adopt a child
and give their relationship a new lease on love.
They are both deeply excited and wait for Ethan
with both joy
and a little fear that they won't be up to the task!

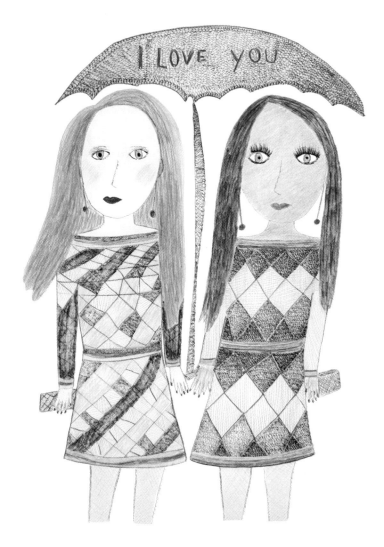

Speed-dating love

Vita decided to find a husband,
whatever the cost.
Every day, she had lunch with a stranger.
Today, after 120 lunches and a year of waiting,
at last she has found the right man.

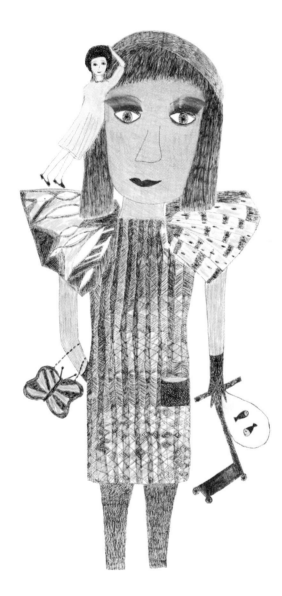

Love in the mirror

Jean and Vivienne study fashion design together.
They have created a clothing line and a foundation
for the protection of biodiversity in Antarctica.
They are spreading their love of life.

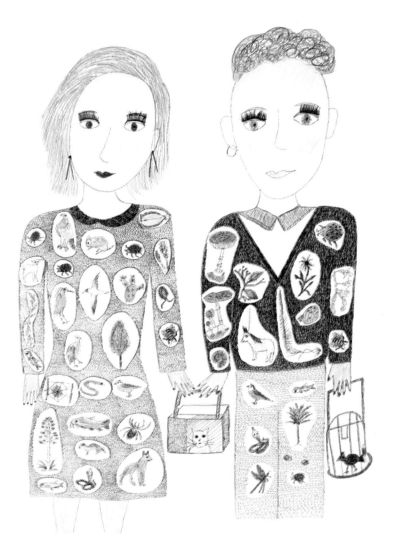

Surprising love

Benjamin is going to meet Pomme.

It is his first date.

He is not worried—he knows girls like him.

Surprising love, part II

Pomme is very happy to have met Benjamin.

She's already impatient to see him again.

Is it true love?

About the Author

Aurelia Alcaïs was born in 1975 to a family of artists in Paris, where she still lives. She started her career as a model and actress before beginning writing and creating art. When her son was born, she felt the desire to link all her passions: drawing, writing, fashion, and photography, and she became an illustrator. Her first book, *Quand je serai un animal*, was published in France in 2014.